PHOTOGRAPHY AT THE MUSÉE D'ORSAY

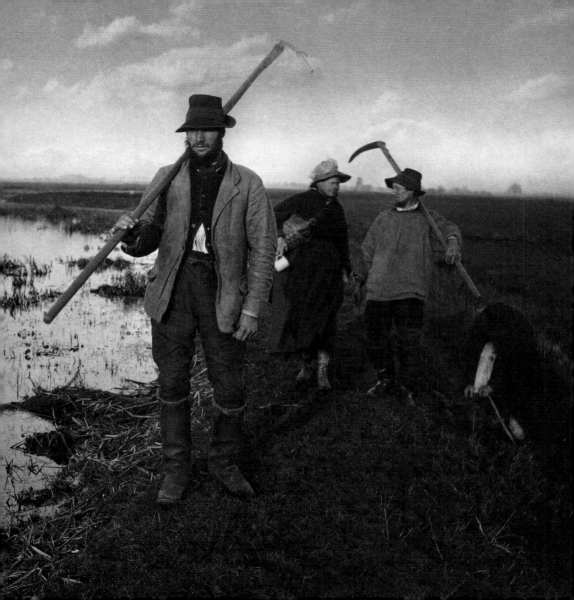

Françoise Heilbrun

Towards Photojournalism

Musée d'Orsay

This collection is directed by Serge Lemoine,
Chairman of the Musée d'Orsay.
All works reproduced in this volume belong
to the Musée d'Orsay's collection
and are kept in the museum.

This book has been conceived for the exhibition
Vers le reportage at Musée d'Orsay,
16th October 2007 – 6th January 2008,
curated by Françoise Heilbrun,
assisted by Saskia Ooms and Laura Braemer.

The author wishes to thank Nina Kallmayer,
Anna Vivante and Frédéric Illouz for their precious
advice and all the people who took part in the installation:
Virginia Fienga, Doris Grunchec, Stéphane Bayard,
Laurent Stanich, Anne Pouchelon, Fabrice Golec,
M. Galliache, Muriel Desdoigts, Cyrille Lebrun,
Bruno Dapaz, Mustapha Naggar, Michel Cavanne,
Patrick Porcher, and the team of Antoine Tasso.

www.musee-orsay.fr
www.fivecontinentseditions.com

ISBN Musée d'Orsay: 978-2-905724-84-7
ISBN 5 Continents Editions: 978-88-7439-434-0

Cover
Thomas Annan
Glasgow: Close no. 46 Saltmarket, between 1868 and 1871
(cat. 31)

For the Musée d'Orsay

Publication manager
Annie Dufour

Assisted by
Virginie Berri

Iconography and digitalisation
Patrice Schmidt and Alexis Brandt

For 5 Continents Editions

Editorial Coordinator
Laura Maggioni

Design
Lara Gariboldi

Layout
Daniela Duminuco

Translation
Julian Comoy

Editing
Andrew Ellis

Colour Separation
Eurofotolit, Cernusco sul Naviglio (Milan), Italy

Printed in October 2007
by Leva Arti Grafiche, Sesto S. Giovanni (Milan), Italy

Printed in Italy

Table of Contents

Towards Photojournalism 6

Entries 22

Selected Bibliography 30

Plates 32

Françoise Heilbrun

Towards Photojournalism

"... a beggar held his hat out to me with one of those unforgettable looks which could topple a throne."

Charles Baudelaire, *Let's Knock Out the Poor*, in *Le Spleen de Paris*

The term reporter indicates a journalist who investigates a given subject. The word passed into the French language in the early nineteenth century at a time when the press was in full expansion. Photojournalism as such developed in the twentieth century with the invention of new cameras and the explosion of illustrated magazines. This step depended on the simultaneous printing on an industrial scale of the photo and text as a combined unit, which became possible at the turn of the past century.

The investigations which the major newspapers gave their reporters had actually already been in existence since the printing of photos on paper was invented, in the early 1840s, but they were destined to remain relatively confidential. To publish books illustrated with photographs was an expensive process and was rarely undertaken, and the direct introduction of photography in print was further delayed by the endurance of the traditional practice of using drawings and engravings. The ancestors of modern photojournalists have been unearthed over the past thirty years or so. Indeed, the recent D.A.T.A.R. socio-cultural photographic exploration of France took as its starting point the 1851 *Mission héliographique* (Heliographic Assignment), the first great official commission awarded to French photographers.

This essay is based on the Musée d'Orsay's collections and concentrates on reportage on social questions and its first fruits. It aims to show how photographers during the nineteenth century saw the silent majority of society made up of workmen, craftsmen, peasants, the poor and unqualified, or peoples as yet untouched by Western civilisation. It is after 1848 that historical dignity—to use Professor Robert Herbert's expression—began to be restored to "common people",

becoming one of the favourite topics of philosophers, writers and painters, before being taken up by reformers. Photographers naturally followed suit. The series of photographs selected were taken in various different conditions, whether artists' or enthusiasts' exercises of full-blown social studies, but they all share this hailing of the new heroes, as surely as did the works of the painters Daumier, Courbet, Millet, and Doré. First of all, they make their existence visible as the representatives of a social class, then in the early twentieth century, with the help of the growth of a social conscience and improvements in technology, they were viewed as individuals in their own right.

Les pêcheurs et des femmes de Firth of Forth [*Fishermen and Women of the Firth of Forth*] (1843, Scotland) can be regarded as the first case of photojournalism worthy of the name. In 1844 the painter David Octavius Hill and his associate the photographer Robert Adamson announced the publication of a book illustrating the lives of fishermen in the north of Scotland, whom they had just photographed at work—as far as the technology permitted—and at leisure. The little port of New Haven, where they had stood their tripods, already attracted a few tourists, and the writings of Walter Scott and paintings of David Wilkie, exalting the nobility of peasant life, had inspired them. In fact, the publication was never distributed at all. It was to include some sixty photos, some of which ended up in collectors' albums and were exhibited the year in which they were taken at the Scottish Academy in Edinburgh, then at the Académie des Beaux-Arts in Paris and finally at the Great Exhibition in London, in 1851. As isolated works, these photos were judged on their aesthetic qualities, which were real and deliberately introduced by their authors. A contemporary critic did not hesitate to compare the photos of the portly New Haven women with the ancient "matrons" of the Parthenon reliefs. But these works are best appreciated as a group—first exhibited in 1991 at the National Portrait Gallery of Edinburgh, then in Paris at the Musée d'Orsay—and go beyond the merely picturesque to reveal the photographers' real interest in their subjects, who are often identified by name (cats. 2, 3). Although they might not look into the lens, this is only because of the sunlight and the length of the exposure.

Charles Nègre, the first street photographer, 1851–55

Charles Nègre, a pupil of Paul Delaroche, must have seen the pictures of Hill and Anderson when they were shown in Paris by the painter Ary Scheffer. He was the first French photographer of the 1850s to have systematically photographed peasants of his native Midi and the common people of Paris he came across near the Seine. He had chimney-sweeps, rag-and-bone men, farmers, coconut sellers, organ grinders, masons, and pipers pose for him in the courtyard or in front of the facade of 21 Quai Bourbon, where he had his studio. Like Hill, at first he used his photos only as the basis for his paintings. Although he occasionally deliberately composed scenes, he generally snapped his subjects as he found them. His *Marché au port de l'Hôtel de Ville* [*Town Hall Port Market*] (a picture lent to the Musée d'Orsay by Madame Suzanne Winsberg PHO 2002 2 1), his *Chiffonnier* [*Rag-and-Bone Man*] (cat. 1) and his *Ramoneurs* [*Chimney-sweeps*] (cat. 5) were admired by the critics of *La Lumière*, the review of the Société Héliographique, especially by Francis Wey, a friend of Courbet's. Nègre connects the literary and pictorial traditions—*Les Cris de Paris* drawn by Bouchardon and engraved by Caylus, for example—and twentieth-century street photography (Brassaï, Doisneau, Cartier-Bresson, Walker Evans, etc.). Nègre was not the only photographer attracted by these subjects, but he was able to lend them a maximum of realism and humanity, as displayed in the faces of his chimney-sweeps or his organ grinder. Disderi was to produce several types taken from the common people, which were quite skilfully done, but included predictably picturesque aspects. In London, young beggars posed for Oscar Rejlander in his studio. He also exhibited and sold his prints, one of which is thought to have been used on a charity poster. John Thompson was the first to use his pictures in a campaign against poverty in his *Street Life in London*, published in 1877, but these were often conventional shots. In 1857, Nègre was commissioned to produce the first photographic record of a social topic to commemorate the establishment of the Asile de Vincennes by the emperor Napoleon III. This hospital was

designed to accommodate labourers injured on building sites and factories, who, unlike soldiers, were unprotected. The photos were published in albums distributed to high-ranking administrators of the empire, then exhibited in 1859 at the Société Française de Photographie. They give an insight into the lives of the patients as they passed the time in the gardens, dining room, library, etc., as well as that of the kitchen and laundry staff (cat. 6), and nurses. Exalted by the treatment of the light, these labourers are turned into a radiant community (cat. 7). The idea behind this type of report is still up to date now, even in this form, which adopts the viewpoint of the administration rather than that of the patrons, who are shown from a distance, shorn of their individual characteristics.

War seen from an everyday perspective: Roger Fenton in the Crimea

As is well known, the Crimean War, one of the chief conflicts of the century, was the first war covered by the media. The publisher and art dealer Thomas Agnew hired Roger Fenton, who enjoyed the patronage of Queen Victoria, to make a photographic report on the conflict viewed from the British side. With the advent of photography, war ceases to be the heroic subject it had been in painting until the Romantic period, since this medium did not enable artists to work actually on the field of battle. The photographer was thus led to concentrate on the background to the battle and its preparations, including the arrival of the victuals and ammunition in the docks (cats. 8, 9) and daily life in the camp, to which Fenton dedicated an entire album, in which it must be admitted the other ranks are generally treated as accessories. At times, the limits of the technology and official rhetoric obliged the photographer to compose scenes which are rather artificial, and contemporary critics duly remarked on the fact. But in his long-distance view of Balaclava, this great artist manages to imbue these preparations with a breath of the epic (cat. 10). At the time war was still considered a glorious endeavour

and it was out of the question to show that it was in fact pure carnage by displaying bodies, other than through the medium of drawing (as Constantin Guys did for the *Illustrated London News*). In its brutal simplicity—a desolate plain strewn with cannonballs—*The Valley of the Shadow of Death* (cat. 11), as it was known by British soldiers, who were driven back several times by the Russians in this very place, is an eloquent symbol of the horror of war, but a symbol which remains abstract. This photograph has become a mythical image today, and it was admired at the time too, notably by Ernest Lacan, the editor of *La Lumière*. Fenton's photos were exhibited throughout England in 1855 and shown later in Paris, and were sold in London, Paris and New York, before being copied by engravers for magazines, such as the *Illustrated London News*.

George Barnard and General Sherman's campaign during the American Civil War

The dead had been carefully airbrushed out of the photos of the Crimean War. Felice Beato was the first to depict bodies, those of Chinese killed in the French storming of Fort Takou, in 1860, during the Opium War. Three years later, Timothy O'Sullivan and unknown others photographed for Matthew Brady the soldiers who fell at Gettysburg in the American Civil War. George Barnard, who had been hired by the Union Army to follow Sherman's campaign in Virginia and the Carolinas, opted against giving explicit details. His album, which he sold by subscription after the war, contains only pure landscapes illustrating the military strategy underlying the operations, alongside a few pictures discretely yet effectively suggesting the fierceness of the clashes: the ruins of a railway depot marking the fall of Charleston, the heart of Confederate resistance (cat. 13), shattered fortifications, blasted branches, and clothes hanging in shreds on a line to convey the assault in torrential rain on New Hope Church—"the hell hole", as the soldiers called it, a stronghold in the Southern defences (cat. 12).

The Rhône Floods by Édouard Baldus, June 1856

Fenton and Barnard successfully conveyed the essence of disaster, not by manipulating the subject, but through their skill in choosing the most significant point of view. The same aesthetic preoccupations can be found in the photographic record produced by Baldus on behalf of the Ministry of the Interior of the Rhône floods of 1856, a subject which acted as a source of inspiration for numerous painters and photographers. Torrential rain had struck the whole country at the end of May and flooded entire quarters of Lyon, Avignon, and Tarascon, leaving thousands homeless. Baldus hurried there with an assistant for eight days in June and took some thirty pictures depicting the damage to the countryside and buildings, two fields in which the photographer was a master. In spite of there not being a single human being —with the negative paper technique used, the photographer had to choose between the figure and the background—these images of submerged houses (cat. 14) or burst dykes (cat. 16) make it easier for us to appreciate the extent of the catastrophe than the painstaking paintings exhibited at the Salon the following year, portraying Napoleon III bringing solace to the flood victims. Baldus' photographic record was never published, nor were the pictures used as models for woodcuts, but nonetheless it was highly praised by Ernest Lacan in *La Lumière*: "It is with a feeling of the deepest sadness that one examines these views … which are unfortunately all too eloquent. … These are extremely sad pages, but in truth they are beautiful." These pictures were to find their way into the collections of certain enthusiasts, such as Victor Regnault, or Léon Bourquelot.

Portraits of Micmacs taken by Miot at the request of the Comte de Gobineau, 1857

The nineteenth century saw the rise of anthropology, for which photography was an invaluable tool, albeit descriptive rather than properly scientific, even when it pretended to be. The portraits of all the "races", widely disseminated by the fashion for World Fairs and magazines like *Le Tour du Monde*, were of interest mainly to enthusiasts and collectors, whose ideal representative was Roland Bonaparte, who donated all his collection to the Société Française de Géographie. The naval ensign Paul-Émile Miot regularly sent his drawings to the review *L'Illustration*—he soon turned to photography—to provide a record of his voyages, before setting up the naval photographic studio. When on a hydrographic expedition to Newfoundland for Admiral Cloué, he met the Comte de Gobineau, a French diplomat who at the time was part of a Franco-American commission inspecting the French coast. Gobineau had just written his essay *L'Inégalité des races humaines* [*The Inequality of Human Races*], and Miot had just photographed the Newfoundland fisheries. The writer asked him therefore to photograph the local Micmac Indians, who were of princely descent but who had fallen into the greatest poverty (cats. 18, 19), about which he wanted to write in his forthcoming *Voyage à Terre-Neuve* [*Voyage to Newfoundland*]. This report was to be republished five years later in the review *Le Tour du Monde*, illustrated with woodcuts by Rousseau based on photos by Miot. In this case, the sailor took real individual portraits, displaying the same empathy as the Comte de Gobineau when the latter describes these natives at length, and with heartfelt emotion, particularly *Gougou* (cat. 18), a touching figure whose portrait was later to inspire Picasso.

Désiré Charnay on assignment in Madagascar, 1863

The explorer Désiré Charnay had earned a certain renown with the publication of his photographic atlas of the Pre-Columbian cities and ruins in Mexico. He was thus invited in 1863 to take part as historiographer and photographer in a three-month official expedition to Madagascar, whose aim was to extend French political influence. Prince Radama II, who had ascended the throne two years previously, had just been assassinated after making a declaration of perpetual friendship with France, and the members of the expedition were rather coolly received by the followers of the new leaders, the "terrible" Hovas. The explorer preferred the "mild" Malagasy, who took a favourable view of European civilisation. Charnay wrote a chronicle of the expedition, published the following year in *Le Tour du Monde*, which was illustrated with woodcuts based on his photographs, and was soon translated into English, *Bird's-Eye View of Madagascar*. His original pictures were gathered together in a small number of albums. Among the photos are detailed pictures of the flora and fauna, which was of the greatest interest to this follower of Humboldt, and of villages (cat. 20) and their inhabitants. At the capital Tamatave, where he assited to the crowning of Queen Fiche, Charnay took the photograph of Raharla, the prime minister of the Queen, who had all his sympathy (cat. 23), and of his retinue (cat. 22). He showed the Malagasy in traditional costumes (cat. 21) and sometimes in everyday activities such as pounding rice, carrying packs (cat. 24), or naked, seen from behind, in three-quarter view, or in profile. Charnay's profiles are full length, with a short focal length, isolating the background so as to make evident the occupation, the costume, and if necessary the expression of the face. His approach is more aesthetic than scientific. He is interested for example in the beauty of the fabric (cats. 22, 25) and in the way the light models bodies (cat. 27), displaying a sensuality well served by the sumptuousness of the photos.

The Glasgow slums pictured by Thomas Annan in 1868

At the time when Thomas Annan photographed Glasgow, the population of the city had been increasing rapidly for thirty years or so. The well-to-do had moved out of the eastern part of the city, which was now overpopulated by Irish immigrants fleeing from the famine, and Highlanders come to find work in the mills and the chemical and metal works. The trustees of the *Improvement Act* drew up the first slum clearance programme for the city in 1868. They asked the Scottish photographer Thomas Annan to photograph the alleys in the impoverished old quarters situated around the High Street (cat. 29) and Saltmarket (cats. 28, 30, 31), which they planned to replace with wider avenues serving new housing developments. At the same time, Charles Marville was photographing the condemned streets of the old Paris for the Commission des Monuments Historiques, created by Haussmann. While Marville completely eliminated all human presence from his shots, Thomas Annan's pictures contained some of the inhabitants of the slums, including several children, which lends his series a feeling of greater social awareness. In 1878 Marville's photographs were displayed at the Great Exhibition in Paris to mark the completion of Haussmann's scheme. One year previously, the trustees of the *Improvement Act* had put Annan's forty photos on show at Kelvingrove Park Museum in Glasgow; they also had a hundred copies specially republished for the occasion in the form of permanent carbon prints, a new technique. The images these two photographers were able to conjure up are so powerful that even now their spell is undiminished. In 1900 a third, photo-engraved edition by Craig Annan, the son of Thomas, accompanied the final phase of slum clearance in Glasgow.

Emerson, an emulator of Jean-François Millet, 1886

The turn of the century was a decisive period in the growth of amateur photography. Cameras became lighter, their mechanics became simpler and standardised, their price dropped, and new emulsions led to faster shutter speeds, enabling fleeting moments to be captured. Virtually anybody could become a photojournalist by following up a subject of general interest. We owe to certain amateur photographers, often following in painters' footsteps, some of the most remarkable series of pictures of peasants or scavengers living off the discards of coal mines. These were the subjects which in literature and painting had made the reputations of figures such as Daumier, Millet, Victor Hugo, and Zola.

Peter Henry Emerson, the son of a wealthy Cuban landowner and an English mother, gave up a medical career in order to dedicate himself to photography, and moved to Great Britain. Following in the footsteps of the painter Jean-François Millet, who had a considerable influence on him, he decided he would champion the cause of the inhabitants of the Norfolk Broads (cats. 34, 35) and East Anglian sailors in general (cat. 33), whose life he shared in the late 1880s and whose activities he recorded with the same concern for truth and nobility as the author of *Glaneuses* [*The Gleaners*]. Emerson regarded his photographs, often taken together with the painter and naturalist Thomas F. Goodall, as a way of bearing witness and made a point of having each set published in book form. In this he was faithful to the spirit of photojournalism. However, he was also addressing a public of connoisseurs of photography and was unyielding in his aesthetic and technical standards. He had set out his approach to photography in his treatise *Naturalistic Photography*, which owed much to the theories of perception which had underscored Impressionism. He made a point of printing all the plates of *Life and Landscape of the Norfolk Broads* himself on platinum-coated paper, which lent great subtlety to half-tones. These pictures of the lives of English peasants and sailors captured by Emerson have become classics.

Félix Thiollier, an amateur inspired by the poor living near mines

Félix Thiollier was also a child of the well-off, cultivated bourgeoisie. His family owned a ribbon factory at Saint-Étienne, as well as land in the surrounding countryside. He lived surrounded with painters, like Jean-Paul Laurens and Ravier, took an active part in preserving his region's archaeological heritage, wrote and published works on contemporary artists, and took thousands of photographs, which he never exhibited and virtually never published. This is all the more surprising since at this time all amateurs with means were members of photographic clubs and exhibited throughout the world. Thiollier took hundreds of pictures recording, among others, the lives of these scavengers, foragers of the industrial world who came with their families to root around the waste of the coal and steel industries. If these pictures had been published in the illustrated magazines, they would have been distributed on a worldwide scale, such was the emotive punch they packed. Thiollier worked preferably, but not exclusively (cat. 46), in the evening and took mainly long-distance shots, so as to produce clear silhouettes of the labourers (cats. 48, 49), on whom he tried to confer a heroic monumentality. The aesthetic concerns of this artist, who undoubtedly would have liked to have been a painter too, do not prevent him giving us an invaluable record of a world which has now vanished.

Henri Rivière visiting the Eiffel Tower, 1889

The engraver Henri Rivière was also a highly talented amateur photographer, although his technique lacks the beauty and perfection found in Emerson's pictures. He was the typical "flâneur", and, equipped with a light camera and small glass plates, he wandered around Paris taking pictures of what the bustling street life offered: shopkeepers, bourgeois, pastry cooks, open-topped

buses, anything that caught his eye. He visited the Eiffel Tower just after construction had been completed, together with Rudolphe de Salis and the entire company of his Chat Noir cabaret, where he photographed the architecture and the workmen applying the finishing touches. Seeing the painters hard at work hanging in mid-air (cats. 36, 38, 39), one cannot help but think of the pictures that Moholy Nagy and Lewis Hine, both champions of the working class, would later take themselves. As for Rivière, it was never his intention to give his photos wide circulation; he used them as sources for his work as a lithographer. What interested him in this case was form. The Eiffel Tower enabled him to produce any number of daringly composed pictures, with low- and high-angled shots. Besides, the silhouettes of the building painters and iron girders standing out in black against the white of the sky inevitably attracted the interest of the inventor of the shadow theatre of the Chat Noir cabaret (cats. 36, 37).

Lewis Hine, a reformer

Lewis Hine is the perfect representative of those reformists who in late nineteenth-century America decided to do something about the negative aspects of capitalist society, using the very means this society placed at their disposal: photography, the press, and advertising. He knew what he was talking about: while still a teenager, he was working thirteen hours a day for a pittance. Encouraged by two figures of the first rank in this social movement, Frank Manny and Paul Kellogg, Hine attended courses at Chicago University, a breeding ground of progressive ideas, and taught at the Ethical Culture School in New York, for which he photographed immigrants arriving at Ellis Island at a time when a section of the population wanted to reduce the influx in order to protect American identity. The fine portraits which Hine took were published in the reformist magazine *Charities and the Commons*. The artist wanted to show that these

foreigners had their nobility too, and did not hesitate to give an Italian peasant woman the appearance of a Madonna (cat. 41). He worked on the Ellis Island project until 1909 and returned there some twenty years later, when the question of reducing the number of immigrants again became a matter of controversy (cat. 40). One of the projects he was most involved in was the campaign led by the Child Labor Committee against child labour in factories (cats. 42, 44), in the street (cat. 43), in illegal workshops and at home (cat. 45). These pictures taken throughout the country were accompanied by captions written by the photographer himself, giving details of the location and the age of the children, so as to provide irrefutable proof to use against those who denied that such a thing as child labour existed at all. They were published in *Survey* (the new title of *Charities*), projected as slides at the numerous conferences Hine held, or displayed in exhibitions or on posters. At the same time, Lewis Hine also ran a photo club. He would take his students to see Alfred Stieglitz's Gallery 291, since he was not impervious to aesthetic considerations; it was just that in his case formal qualities had to serve the purpose of the picture.

Paul Strand, a committed artist

From 1907 Lewis Hine's pupils included the young Paul Strand, a follower of Alfred Stieglitz. The latter had encouraged him to seek technical and formal perfection and jettison all painterly flummery, while Hine roused his social conscience. In 1916–17, in the last two issues of *Camera Work*, Strand placed side by side with Cubist-influenced views of New York large-scale portraits taken with a miniature detective camera (cats. 56–59). Strand had certainly seen the mug shots of ordinary people taken by Adolphe De Meyer and previously published in *Camera Work*, by Stieglitz, but, rejecting all decorative excesses, he managed to inject a greater sympathy in his own portraits, as well as a greater stringency. His merciless portrait of a blind man (cat. 58) is a real

emblem of modernity, like Duchamp's famous contemporary *Urinoir*. More and more drawn to depicting simple and hardworking communities, peasants from Mexico (cats. 60–62), Italy or France, where he was to end his life, Strand continued to take his large-scale portraits, but turned to a Graflex single-lens reflex camera, and combined his interest in form and the individual's humanity with a touch of sentimentality (cat. 61), especially in the Mexican album.

On the veracity of the photojournalistic "report"

The aim of these records is not the only question which arises. There is also the matter of credulousness and staging, which almost all combine in some measure. In the case of Charles Nègre, for instance, this is quite plain, and it is likely, if not certain, that Thiollier and Emerson also gave their models some instructions on how to "replay" their typical everyday activities. Hine himself composed his portraits of immigrants at Ellis Island (cat. 41), Paul Strand did the same with Mexican peasants and Bill Brandt went so far as to ask some friends to pose for him to make his pictures of miners more satisfying compositions; at the end of the day, taking certain liberties with "reality", for dramatic effect, is and has always been an effective weapon in the photographer's armoury in trying to express it fully.

Photographic record of the Jewish communities in Poland. Around 1919

The Polish Constructivist painter Henryck Berlewi, a Jew, preserved eighty pictures from a photographic record commissioned by an American charity created in 1914, the Jewish Joint Distribution Committee. When these photographs were donated to the Musée d'Orsay by the Jean Chauvelin

Gallery, which received them from Berlewi, they were without any context, but this was partially reconstructed thanks to a number of clues. Certain outdoor views certainly depict Warsaw. Crowds are shown gathering outside a building with a banner bearing the name of a charity, milk is being handed out to children in an interior, inscriptions combine Cyrillic script, Polish names, and Hebrew characters. This organisation funded the aid given to the Jewish communities fleeing from pogroms in the Ukraine. Men, women and children were photographed at times against a wall and sometimes in what can barely be described as an interior (cats. 50–53). Like Hine's pictures, these were work documents for those who wanted to improve the refugees' lot, and were not meant to be hung on a museum wall. But isn't it precisely in a museum that one finds that "sacred space" mentioned by Susan Sontag, that "space for meditation in which one can look at the images of pain"? And if, at the end of the day, the representation of poverty and suffering, whether aesthetically pleasing or not, contributes even a little to making us better human beings, they will not have been shown in vain.

Entries

1. **Charles Nègre** (Grasse, France, 1820–80), *Le Petit Chiffonnier appuyé contre une borne devant le 21 quai Bourbon à Paris* [The little rag-and-bone man leaning against a bollard in front of 21 Quai Bourbon in Paris], 1851. Dry-waxed paper negative, 14 x 10.4 cm.
PHO 1981 2
This photograph and its variant were discussed in *La Lumière*, on 18 May 1851, by Francis Wey.

David Octavius Hill (Perth, Scotland, 1802 – Newington Lodge, Edinburgh, Scotland, 1870) and **Robert Adamson** (Saint Andrews, Scotland, 1821–48).
Photographic record of the fishermen and women of the Firth of Forth.

2. *Willie Liston Redding the Line*, 1843. Positive calotype, 19.8 x 14 cm.
PHO 1980 264

3. *Jeanie Wilson, New Haven Fisherwoman*, 1843. Positive calotype, 20.3 x 30.2 cm.
PHO 1983 83

Charles Nègre (Grasse, France, 1820–80)

4. *Moulinier travaillant sous le regard d'une paysanne* [Twister at work watched by a peasant woman], 1852. Print on salted paper from a dry-waxed paper negative, 20.3 x 15.9 cm.
PHO 2002 1 6
When he made his essentially architectural photographic record of the French Midi in 1852, Nègre took the opportunity to photograph peasants at work.

5. *Trois ramoneurs au repos, quai Bourbon* [Three chimney-sweeps at rest, Quai Bourbon], autumn 1851[?]. Dry-waxed paper negative, 16.8 x 20 cm.
PHO 1981 3
Nègre took a series of photographs of chimney-sweeps along the Quai Bourbon at the time when Daumier was painting laundresses on the Quai d'Anjou. These prints were also discussed—and compared with the works of Rembrandt and Murillo—in the review *La Lumière*, on 12 May 1852.

6. *Asile impérial de Vincennes, la lingerie* [Imperial hospice of Vincennes, the laundry], 1857. Print on albumen-coated paper from a wet collodion glass negative, 37 x 26.1 cm.
PHO 2002 1 11

7. *Asile impérial de Vincennes, le réfectoire* [Imperial hospice of Vincennes, the refectory], 1857. Print on albumen-coated paper from a wet collodion glass negative, retouched with ink, 32.8 x 42 cm. Gift of the Kodak-Pathé Foundation.
PHO 1983 165 49
The Vincennes hospice was created in 1855 by Napoleon III.

Roger Fenton (Crimble Hall, England, 1819 – London, England, 1869).
Photographic record commissioned by Agnew of the Crimean War seen from an English perspective. Formerly in the collection of Roger Fenton's brother.

8. *The Ordnance Wharf, Balaklava*, 1855. Pl. 53. Print on salted paper from a wet collodion glass negative, 21.1 x 25 cm.
PHO 2005 4 1

It was Russia's aim in the mid-nineteenth century to dismantle the Ottoman Empire and this led to a war in the East which lasted from 1853 to 1856. The port of Balaklava, in present-day Ukraine, acted as a base for the British troops.

9. *Head of Harbour, Balaklava*, 1855. Pl. 205. Print on salted paper from a wet collodion glass negative, 25.7 x 36.8 cm.
PHO 2005 4 5

10. *Landing Place, Railway Stores, Balaklava*, 1855. Pl. 31 in the album. Print on salted paper from a wet collodion glass negative, 25.7 x 36.5 cm.
PHO 2005 4 3

11. *The Valley of the Shadow of Death*, 1855. Pl. 218 in the album. Print on salted paper from a wet collodion glass negative, 28.4 x 35.7 cm.
PHO 2005 4 2

George Barnard (Coventry, United States, 1819 – Cedarvale, United States, 1902).
Views of Sherman's Campaign album, published in 1866.

12. *Battlefield of New Hope Church*, 1866. Pl. 26 in the album. Print on salted paper from a wet collodion glass negative, 25.6 x 35.5 cm.
PHO 1983 229 26
During the American Civil War, George Barnard was given the job of following General Sherman during his campaign through Georgia and the Carolinas in 1864 and 1865; Sherman's victories over the Confederates were decisive for the result of the war.

13. *Ruins of the R. R. Depot in Charleston, South Carolina*, 1865. Pl. 61 in the album. Print on albumen-coated paper from a wet collodion glass negative, 25.6 x 35 cm.
PHO 1983 229 61

Édouard Baldus (Grünebach, Germany, 1813 – Arcueil, France, 1889). Photographic record of the Rhône floods of 1856, commissioned by Napoleon III's Ministry of the Interior.

14. *Inondations du Rhône à Lyon, Les Brotteaux* [Rhône Floods in Lyon, Les Brotteaux], June 1856. Print on salted paper from a gelatine-coated paper negative, 30.5 x 43.5 cm. Gift of the Société des Amis du Musée d'Orsay, formerly in the collection of Léon Bourquelot, inspector of works of the Réunion des Tuileries at the Louvre.
PHO 1988 8

15. *Inondations du Rhône à Lyon* [Rhône Floods in Lyon], June 1856. Gelatine-coated paper negative, 45.4 x 35.2 cm. Photographic archive deposit of the French Heritage Office.
DO 1982 509

16. *Inondations du Rhône en Avignon, remparts renversés* [Rhône Floods in Avignon, Burst Dykes], June 1856. Print on salted paper from a gelatine-coated paper negative, 32 x 44.5 cm. Archive deposit of Sèvres factory library.
DO 1983 156

17. *Inondations du Rhône à Lyon, Les Brotteaux* [Rhône Floods in Lyon, Les Brotteaux], June 1856. Print on salted paper from a gelatine-coated negative, 33.6 x 44.2 cm. Archive deposit of Sèvres factory library.
DO 1983 150

Paul-Émile Miot (La Trinité-sur-Mer, France, 1827 – Paris, France, 1900)

18. *Gougou, prince micmac* [Gougou, a Micmac Prince], 1857. Print on salted paper from a collodion glass negative, 16.1 x 12.1 cm.
PHO 1987 25 3

19. *Une Indienne micmac* [A Micmac Indian Woman], 1857. Print on salted paper from a collodion glass negative, 19.1 x 14.5 cm.
PHO 1987 25 2
Miot's negatives are held at the Musée du Quai Branly.

Désiré Charnay (Fleurie, France, 1828 – Paris, France, 1915).
Album de Madagascar, Mission de 1863 [Madagascar Album, 1863 Expedition]. Prints on albumen-coated paper from a wet collodion glass negative.

20. *Vue de Mazanga, baie de Bombetok* [View of Mazanga, Bombetok Bay]. Pl. 27 in the album. 17.9 x 27.2 cm.
PHO 1990 4 27
"Are we going to occupy Madagascar?" writes Charnay in his article in *Le Tour du Monde*. "This is not the place to address the question."

21. *Femme malgache et ses enfants* [Malagasy Woman and her Children]. Pl. 3 in the album. 20.5 x 16.6 cm.
PHO 1990 4 3

22. *Hovas de la suite de Raharla* [Hovas in Raharla's Retinue]. Pl. 18 in the album. 21.6 x 16.4 cm.
PHO 1990 4 18
According to Charnay, there were two chief "races" in Madagascar, the Malagasy and the Hovas. The Malagasy

were blacks mixed to varying extents with Kaffirs or Arabs, or with the inhabitants of Mozambique. The Hovas were of Malay origin and had once been regarded as pariahs by the Malagasy, finally escaping from this inferior status in the late seventeenth century. Prompted by the British, they seized power through a bloody coup just before the arrival of the French expedition.

23. *Raharla, Premier ministre de la reine Fiche* [Raharla, Queen Fiche's Prime Minister]. Pl. 22 in the album. 20.3 x 14.6 cm.
PHO 1990 4 22
The court was located at Tamatave on the southwest coast of the island. Queen Fiche, a Malagasy, had married a Hova.

24. *Porteur de paquets* [Porter]. Pl.11 in the album. 18.9 x 13.7 cm.
PHO 1990 4 11
This porter was a Malagasy slave.

25. *La reine de Mohély* [Queen Mohely]. Pl. 34 in the album. 25.1 x 21 cm.
PHO 1990 4 34
France exercised a sort of protectorate over the island of Mohely, which with two other islands makes up the Union of Comoros. Charnay, along with the rest of the expedition, was invited to the island by Queen Jumbe-Souly (1836–78), a Malagasy who had married a Moslem. Throughout her reign, the French authorities were to put pressure on her in order to gain control of the island, which was a slave trading centre.

26. *Femmes malgaches* [Malagasy Women]. Pl. 28 in the album. 19.8 x 15.5 cm.
PHO 1990 4 28
When he writes: "The Malagasy … is good, faithful and devoted. He accepts the white man's superiority

as something natural", or "he has the black's sloth", Charnay expresses the prejudices of his time, but elsewhere he is more discerning and more generous, adding "He is an artist of nature, and has remarkable literary instincts, especially".

27. *"Marou - Malgache - Marou"* [Marou – Malagasy – Marou]. Pl. 30 in the album. 18 x 16.5 cm.
PHO 1990 4 30

Thomas Annan (Glasgow, Scotland, 1829–87).
Photographs of the Old Closes and Streets of Glasgow album, 1871, commissioned by the trustees of the *Glasgow Improvement Act*. Prints on albumen-coated paper from a collodion glass negative.

28. *Glasgow: Closes no. 97 and no. 103 Saltmarket*, 1868. Pl. XXV in the album. 28.5 x 23.2 cm.
PHO 1983 68

29. *Glasgow: Close no. 93 High Street*, 1868. Pl. IX in the album. 28.1 x 23 cm.
PHO 1983 49

30. *Glasgow: Close no. 61 Saltmarket*, between 1868 and 1871. Pl. XXVII in the album. 27.4 x 23.5 cm.
PHO 1983 67

31. *Glasgow: Close no. 46 Saltmarket*, between 1868 and 1871. Pl. XXII in the album. 27.1 x 22.2 cm.
PHO 1983 62

Peter Henry Emerson (La Palma, Cuba, 1856 – Falmouth, England, 1936) and **Thomas Frederick Goodall** (London, 1822–1904)

32. *Coming Home from the Marshes*, 1886. Pl. 1 in the book, *Life and Landscapes of the Norfolk Broads.* Platinum print from a gelatine-silver bromide coated negative, 9.8 x 28.9 cm.
PHO 1981 49 2
Peter Henry Emerson is one of the leading photographers of the 1880s. As the father of pictorialism, he took pure, un-manipulated photographs. He himself made all the prints taken from negatives made together with the painter and naturalist Thomas Frederick Goodall with whom he published most of his books.

33. *In a Sail Loft*, 1890. Pl. XVIII in the book *Wild Life on a Tidal Water*, published in 1890. Photogravure from a gelatine-silver bromide coated glass negative, 16.4 x 19.7 cm.
PHO 1979 81

34. *During the Reed Harvest*, 1886. Pl. 28 in the book *Life and Landscapes of the Norfolk Broads.* Platinum print from a gelatine-silver bromide coated glass negative, 21 x 28.8 cm.
PHO 1981 49 29

35. *Poling in the Marsh Hay*, 1886. Pl. 17 in the book *Life and Landscapes of the Norfolk Broads.* Platinum print from a gelatine-silver bromide coated glass negative, 23.2 x 29.1 cm.
PHO 1981 49 18

Henri Rivière (Paris, France, 1864 – Sucy-en-Brie, France, 1951).
Views taken during a visit to the Eiffel Tower with the Chat Noir company.

36. *La Tour Eiffel – Cinq ouvriers au travail sur une partie du dernier étage du "campanile"* [The Eiffel Tower –

five labourers at work on part of the last floor of the "Campanile", 1889. Silver print from a glass negative, 9 x 12 cm. Gift of Mme Bernard Granet and her children.
PHO 1981 124 4

This great artist was involved in the chief art forms at the turn of the 19th and 20th centuries, ranging from drawing and engraving to the theatre. In his work he attempted to imitate the technique used in the Japanese prints he so admired. He was an amateur photographer of considerable talent, but like his contemporaries Vuillard and Denis, he was active only some fifteen years. The Musée d'Orsay holds part of his collection of photographs.

37. *La Tour Eiffel – Ouvrier debout le long d'une poutre* [The Eiffel Tower – a workman standing at the end of a girder], 1889. Silver print from a gelatine-silver bromide coated glass negative, 12 x 9 cm. Gift of Henriette Guyot-Noufflard and Mlle Geneviève Noufflard.
PHO 1986 122 57

38. *La Tour Eiffel – Peintre sur une corde à nœuds le long d'une poutre verticale, au dessus d'un assemblage de poutre* [The Eiffel Tower – painter on a knotted rope hanging down a vertical girder, above a pile of girders], 1889. Silver print, 12 x 9 cm. Gift of Mme Bernard Granet and her children.
PHO 1981 124 20

39. *La Tour Eiffel – Ouvrier sur échafaudage travaillant sur une poutre verticale* [The Eiffel Tower – labourer on scaffolding working on a vertical girder], 1889. Silver print, 12 x 9 cm. Gift of Mme Bernard Granet and her children.
PHO 1981 124 11

These two views were reproduced in two lithographs in his *36 vues de la tour Eiffel* [*Thirty-Six Views of the Eiffel Tower*] in 1902.

Lewis Hine (Oshkosh, United States, 1874 – Hasting-on-Hudson, United States, 1940)

40. *Syrian Grandmother, Ellis Island, New York*, 1926. Silver print made in 1930 by Berenice Abbott from an original negative with a view to publication, 34.5 x 26.4 cm.
PHO 1984 59

This photograph was taken during Lewis Hine's second assignment on Ellis Island.

41. *Italian Mother, Ellis Island,* 1905. Silver print made in 1930 by Berenice Abbott from an original negative, 34.2 x 23.8 cm.
PHO 1984 58

This photographic record of Italian immigrants arriving at Ellis Island required considerable skill on the part of Hine, who had to operate in poor lighting conditions with a magnesium flash. After using sign language to ask people whose language he did not speak whether they would agree to pose for him, he then had set off the magnesium and closed the shutter before his subjects were blinded by the flash.

42. *A Sweeper in the Hill Factory, Lewston, I saw him working inside*, 1909. Silver print, 12.5 x 12.5 cm. Gift of Harry Lunn.
PHO1986 87

Photographic record of child labour on behalf of the Child Labor Committee.

43. *Young Boys Selling Newspapers, New York*, 1910. Silver print, 11.6 x 9.5 cm.
PHO 1986 45

44. *Hazerville, Interior of Tobacco Shed, Hawthorn Farm, girls in foreground, the ten-year-old makes 50 cents a day, twelve workers in this farm are eight to fourteen*

years old, and about fifteen are fifteen years old, between 1905 and 1910. Silver print, 12.5 x 17.7 cm. Gift of Harry Lunn.
PHO 1986 84

45. *Tenement Workers Making Ornaments*, between 1905 and 1910. Silver print, 12.8 x 17.8 cm. Gift of Harry Lunn.
PHO 1986 85

Félix Thiollier (Saint-Étienne, France, 1842–1914). Prints on barium-coated paper, enlarged from a gelatine-silver bromide coated glass negative. Formerly in the Félix Thiollier collection.

46. *Grappilleurs dans une mine à Saint-Étienne* [Scavengers in a Mine in Saint-Étienne], between 1890 and 1900. 27.3 x 39 cm.
PHO 1997 12 4

47. *Mine à Terrenoire* [Mine in Terrenoire], around 1895. 28 x 40 cm.
PHO 1997 12 5

48. *Grappilleurs au couchant près de Saint-Étienne* [Scavengers at Sunset near Saint-Étienne], around 1895. 28 x 39.5 cm.
PHO 1997 12 11

49. *Grappilleurs sur le terril à Saint-Étienne* [Scavengers on a Slag Heap in Saint-Étienne], around 1895. 23.8 x 37.5 cm.
PHO 1997 12 7
Slag heaps are piles of detritus from coal or iron mines.

Anonymous
Photographic record on behalf of the Jewish Distribution Committee, documenting the Jewish communities driven out by pogroms in Poland in 1919. Formerly in the collection of Henryk Berlewi, gift of Jean Chauvelin through the offices of the Société des Amis du Musée d'Orsay.

50. *Fillette cousant sur son lit* [Girl Sewing on her Bed], around 1919. Silver print, 11.8 x 16.3 cm.
PHO 1991 23 61

51. *Jeune femme dans son intérieur* [Young Woman in her Room], around 1919. Silver print, 12 x 16.3 cm.
PHO 1991 23 65

52. *Petit garçon, debout dans une chambre* [Little Boy Standing in a Room], around 1919. Silver print, 11.8 x 16.3 cm.
PHO 1991 23 41

53. *École juive* [Jewish School], around 1919. Silver print, 12 x 16 cm.
PHO 1991 23 26

Baron Adolphe De Meyer (Paris, France, 1868 – Hollywood, United States, 1946).
Camera Work, October 1912, Pls. XI and XII. Gift of Minda de Gunzburg through the offices of the Société des Amis du Musée d'Orsay.

54. *Mrs Wiggins of Belgrave Square*, 1912. Photogravure from an enlarged original negative, 22 x 16 cm.
PHO1981 31 41
Baron De Meyer, was a considerable pictorial photographer and member of a number of clubs, including the

Linked Ring and Photo Secession, which was set up by Alfred Stieglitz. London was one of this international socialite's bases.

55. *The Balloon Man*, 1912. Photogravure from an enlarged original negative, 22.2 x 17 cm.
PHO 1981 31 42

Paul Strand (New York, United States, 1890 – Orgeval, France, 1979)

56. *Photograph – New York*, 1917. *Camera Work* June 1917, Pl. IV. Photogravure from an enlarged original negative, 23.2 17 cm. Gift of Minda de Gunzburg through the offices of the Société des Amis du Musée d'Orsay.
PHO 1981 35 4

57. *Photograph – New York*, 1917. *Camera Work* June 1917, Pl. VI. Photogravure from an enlarged original negative, 22.3 x 16.5 cm. Gift of Minda de Gunzburg through the offices of the Société des Amis du Musée d'Orsay.
PHO1981 35 6

58. *Photograph – New York*, 1917. *Camera Work* June 1917, Pl. V. Photogravure from an enlarged original negative, 12.8 x 15.8 cm. Gift of Minda de Gunzburg through the offices of the Société des Amis du Musée d'Orsay.
PHO 1981 35 3

59. *Photograph – New York*, 1917. *Camera Work* June 1917, Pl. III. Photogravure from an enlarged original negative, 15.9 x 17.2 cm. Gift of Minda de Gunzburg through the offices of the Société des Amis du Musée d'Orsay.
PHO 1981 35 5

60. *Woman and Boy, Terrancingo*, 1932/33 from *The Mexican Portfolio*, second edition 1967. Heliogravure from an enlarged original negative, 16.4 x 13 cm. Gift of the Kodak-Pathé Foundation.
PHO 1983 165 155 9

In 1929 Strand left for New Mexico to meet up with a group of Stieglitz's followers in Taos. But he was to move further and further away from his mentor's thinking in Mexico, mixing with new friends close to Carlos Chavez's left-wing government. In his search for a social art of his own, Strand decided to portray the native culture in all its forms: peasants snapped in the streets, landscapes and religious architecture and sculpture. In 1940 he published a portfolio with twenty plates, which was reissued in 1967.

61. *Boy, Hidalgo*, 1932/33 from *The Mexican Portfolio*, second edition 1967. Heliogravure from an enlarged original negative, 16.2 x 24 cm. Gift of the Kodak-Pathé Foundation.
PHO 1983 165 14

62. *Young Woman and Boy, Toluca*, 1932/33 from *The Mexican Portfolio*, second edition 1967. Heliogravure from an enlarged original negative, 12.8 x 15.8 cm. Gift of the Kodak-Pathé Foundation.
PHO 1983 165 155 19

Selected Bibliography

BALDWIN Gordon, Malcolm R. DANIEL, and Sarah GREENOUGH. *All the Mighty World: the Photographs of Roger Fenton, 1852–1860*. New Haven–London: Yale University Press, 2004.

BAUDELAIRE, Charles. "Le Spleen de Paris". *Œuvres complètes*, vol. I. Paris: Éditions Gallimard, La Bibliothèque de la Pléiade, 1975.

CHARNAY, Désiré. "Madagascar à vol d'oiseau". *Le Tour du Monde*. Paris: 1864; English ed.: "A Bird's Eye View of Madagascar". *Illustrated Travels*, ed. H. W. Bates. London: Cassell, Petter, and Galpin, 1868.

CLARK, Timothy J. *Image of the People, Gustave Courbet and the 1848 Revolution*. London: Thames & Hudson, 1973.

DAVIS, Keith F. *George N. Barnard: Photographer of Sherman's Campaign*. Kansas City: Hallmark Cards, Inc., 1990.

DAVIS, Keith F. *Désiré Charnay: Expeditionary Photographer*. Albuquerque: The University of New Mexico Press, 1981.

DANIEL, Malcolm, and Barry BERGDOLL (preface by Françoise Heilbrun). *The Photographs of Édouard Baldus: Landscapes and Monuments of France*. New York: Metropolitan Museum of Art; Montreal: Centre Canadien d'Architecture, 1994.

DURAND, Régis and POIVERT Michel. *L'Évenement, les images comme acteurs de l'histoire*. Paris: Jeu de Paume, 2007.

GOBINEAU, Arthur, comte de. *Voyages à Terre-Neuve*. First published in 1869. New edition, Paris: Aux amateurs de livres, 1989.

GREENOUGH, Sarah. *Paul Strand: An American Vision*. New York: Aperture, 1990.

HEILBRUN, Françoise. *Charles Nègre*. Paris: Réunion des musées nationaux, 1980.

HEILBRUN, Françoise, and Philippe NÉAGU. "Baldus, paysages, architectures". *Photographies*, no. 1, spring 1983.

HEILBRUN, Françoise, Philippe NÉAGU, and François FOSSIER. *Henri Rivière, graveur et photographe*. Paris: Réunion des musées nationaux, "Les Dossiers du musée d'Orsay", 1988.

HERBERT, Robert L. *The Rural Image in French Painting from Millet to Gauguin*, Art Form, 8 feb. 1970, pp. 44-55.

KAPLAN, Daile. *Photostory: Selected Letters and Photographs of Lewis W. Hine*. Washington, D.C.– London: Smithsonian Institution Press, 1992.

KRAUS, Hans P. *Sun Pictures: Roger Fenton, a Family Collection*. New York: H. P. Kraus, Jr Fine Photographs, 2005.

"La trame des images. Histoires de l'illustration photographique". *Études photographiques*, no. 20, June 2007.

LEBECK, Robert, and Bodo von DEWITZ. *Kiosk, Eine Geschichte der Fotoreportage, 1839–1973*. Cologne: Steidl, 2001.

LEROY, Yves. "Paul-Émile Miot (Trinité, 1827–Paris, 1900), marin et photographe à Terre-Neuve, iconographie du French Shore". *Annales du Patrimoine de Fécamp*, no. 10, 2003.

McCAULEY, Anne. "Une image de la société", in *Histoire de la photographie*, ed. by Jean-Claude LEMAGNY and André ROUILLÉ. Paris: Bordas, 1996.

MEYEROWITZ, Joël, and Colin WESTERBECK. *Bystander: A History of Street Photography*. London: Thames & Hudson, 1994.

MOZLEY, Anita Ventura. *Thomas Annan, Photographs of the Old Closes and Streets of Glasgow 1866–1877*. New York: Dover Publications, 1977.

SONTAG, Susan. *Regarding the Pain of Others*. Revised ed. New York: Penguin Inc., 2004.

STEINORTH, Karl. *Lewis Hine: Passionate Journey: photographs 1905–1937*. Zurich: Stemmle, 1996.

STEVENSON, Sara. *Hill and Adamson's: The Fishermen and Women of the Firth of Forth*. Edinburgh: National Galleries of Scotland, 1992.

TREUHERZ, Julian. *Hard Times. Social Realism in Victorian Art*. London: Lund Humprhries; New York: Moyen Bell, 1987.

TURNER, Peter, and Richard WOOD. *P. H. Emerson Photographer of Norfolk*. London: Gordon Fraser, 1974.

WEISBERG, Gabriel. *Beyond Impressionism. The Nationalist Impulse*. New York: Abrams, 1992.

Plates

1. Charles Nègre
Le Petit Chiffonnier
appuyé contre
une borne devant le
21 quai Bourbon à Paris
1851

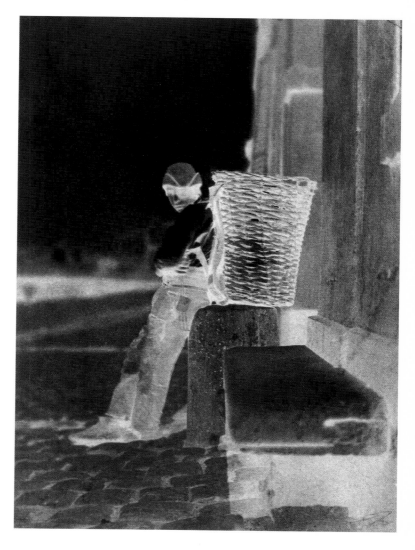

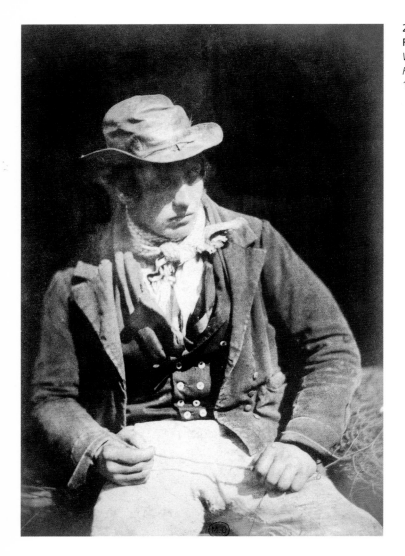

**2. David Octavius Hill,
Robert Adamson**
Willie Liston
Redding the Line
1843

**3. David Octavius Hill,
Robert Adamson**
*Jeanie Wilson,
New Haven Fisherwoman*
1843

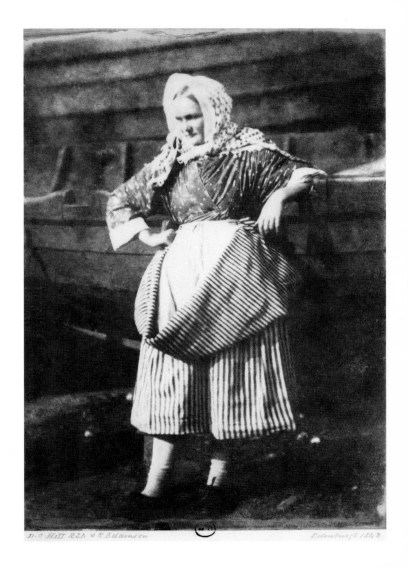

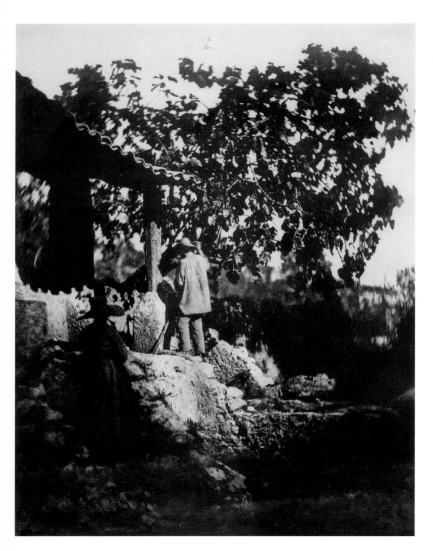

4. Charles Nègre
Moulinier travaillant
sous le regard
d'une paysanne
1852

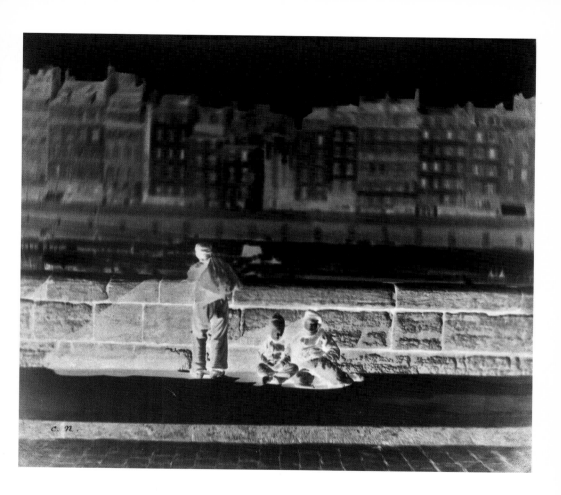

5. Charles Nègre
Trois ramoneurs au repos,
quai Bourbon
1851 [?]

6. Charles Nègre
*Asile impérial de Vincennes,
la lingerie*
1857

7. Charles Nègre
Asile impérial de Vincennes,
le réfectoire
1857

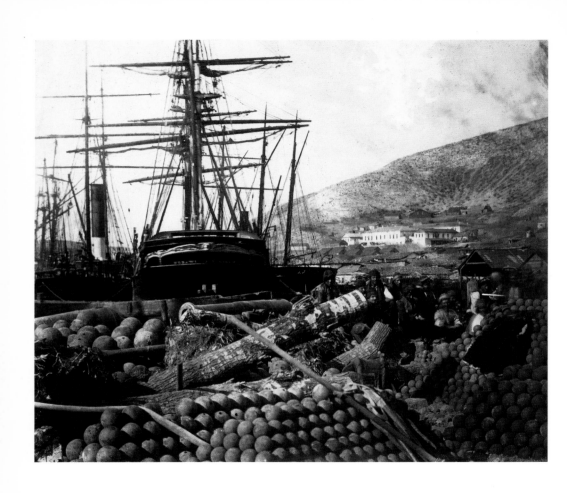

8. Roger Fenton
The Ordnance Wharf, Balaklava
1855

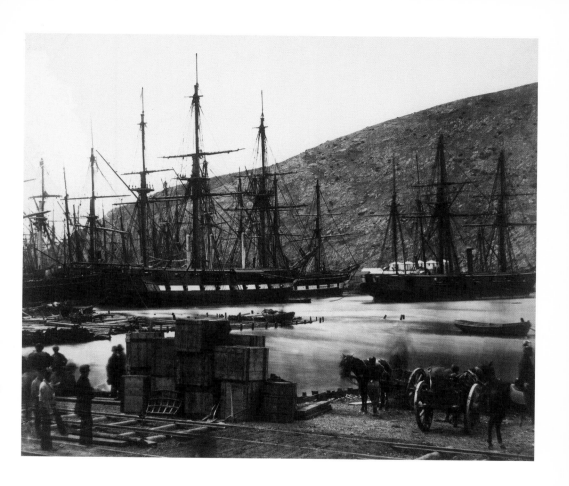

9. Roger Fenton
Head of Harbour, Balaklava
1855

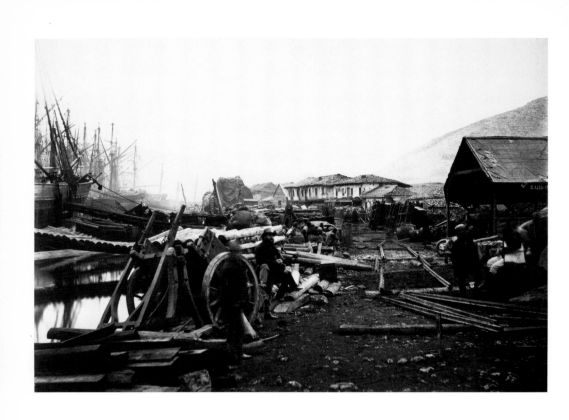

10. Roger Fenton
Landing Place, Railway Stores, Balaklava
1855

11. Roger Fenton
The Valley of the Shadow of Death
1855

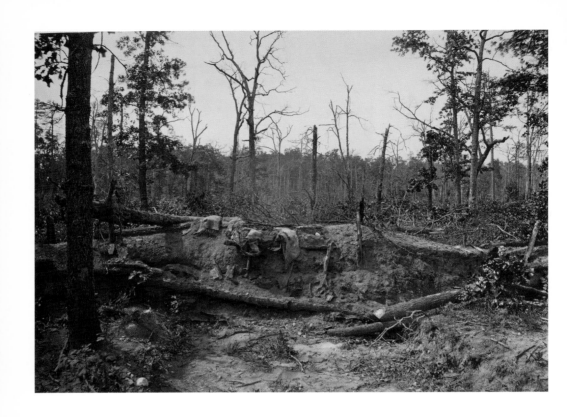

12. George Barnard
Battle Field of New Hope Church
1866

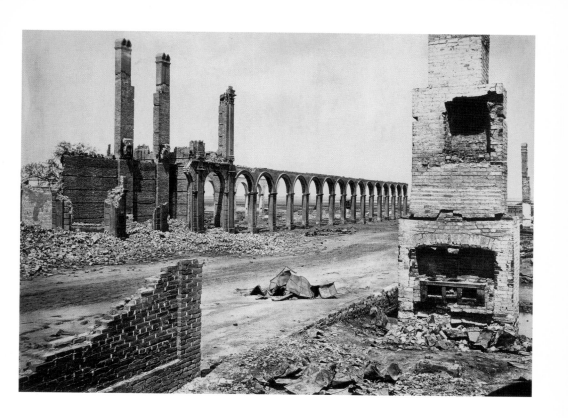

13. George Barnard
*Ruins of the R. R. Depot
in Charleston, South Carolina*
1865

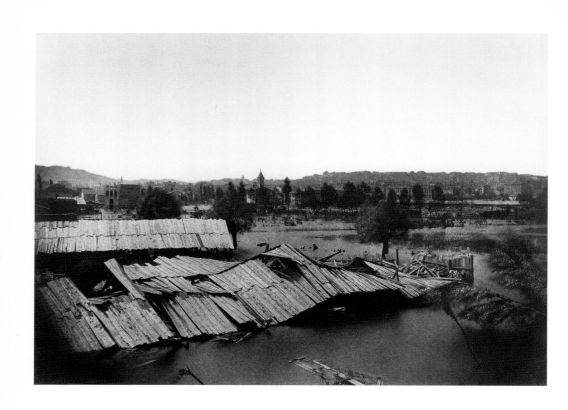

14. Édouard Baldus
Inondations du Rhône à Lyon,
Les Brotteaux
1856

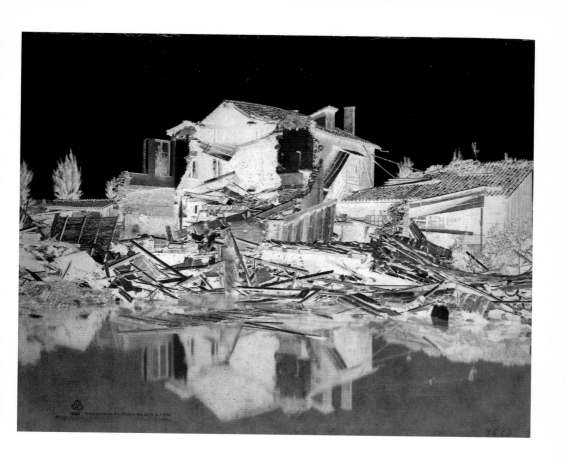

15. Édouard Baldus
Inondations du Rhône à Lyon
1856

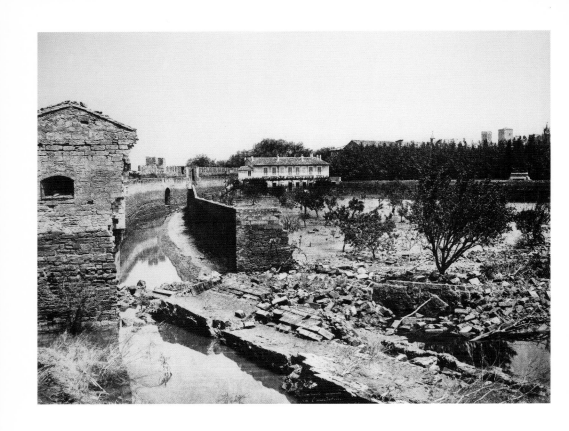

16. Édouard Baldus
Inondations du Rhône en Avignon,
remparts renversés
1856

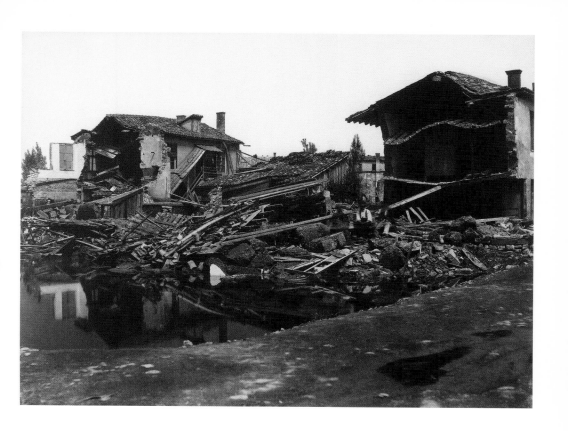

17. Édouard Baldus
Inondations du Rhône à Lyon,
Les Brotteaux
1856

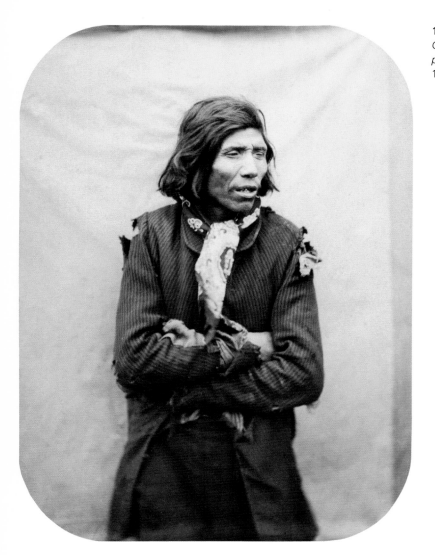

18. Paul-Émile Miot
Gougou,
prince micmac
1857

19. Paul-Émile Miot
Une Indienne micmac
1857

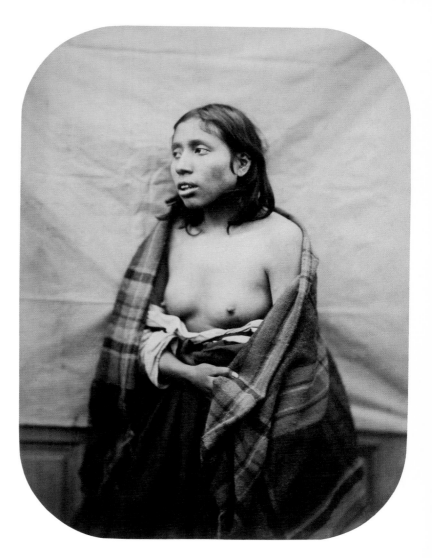

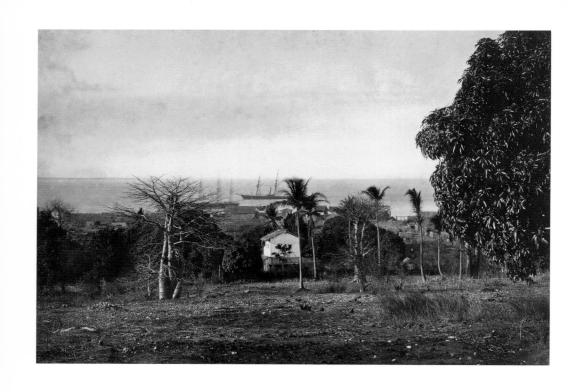

20. Désiré Charnay
Vue de Mazanga, baie de Bombetok
1863

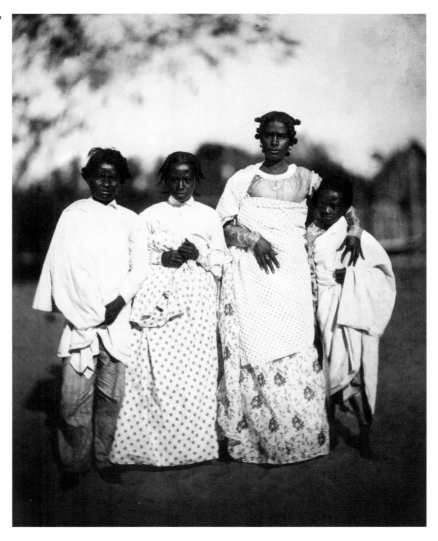

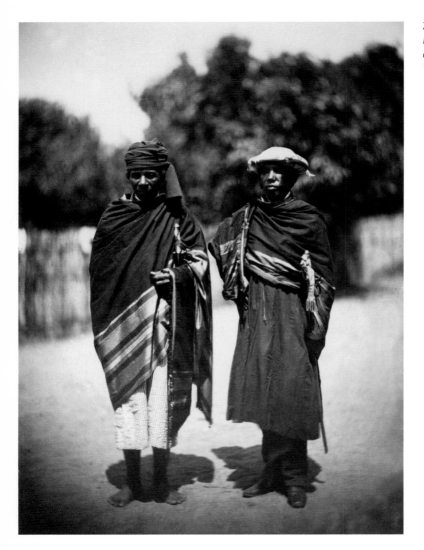

22. Désiré Charnay
*Hovas de la suite
de Raharla*
1863

23. Désiré Charnay
Raharla, Premier ministre
de la reine Fiche
1863

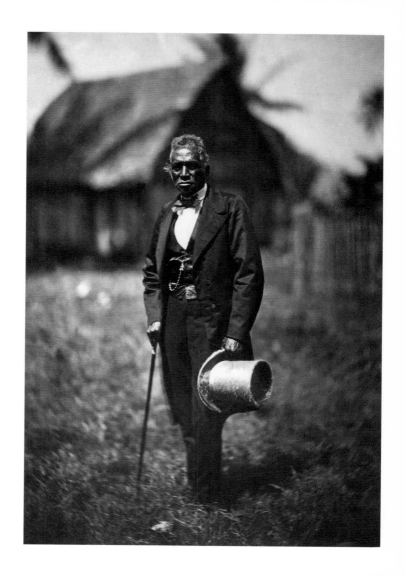

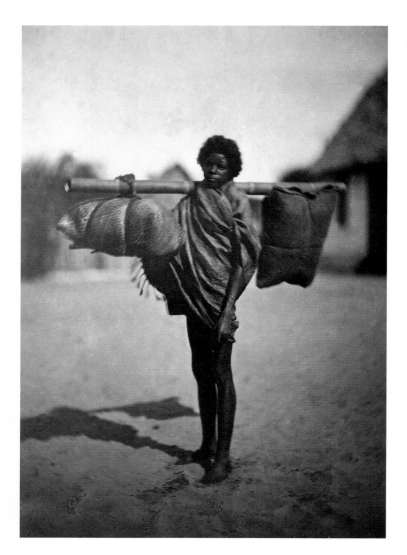

24. Désiré Charnay
Porteur de paquets
1863

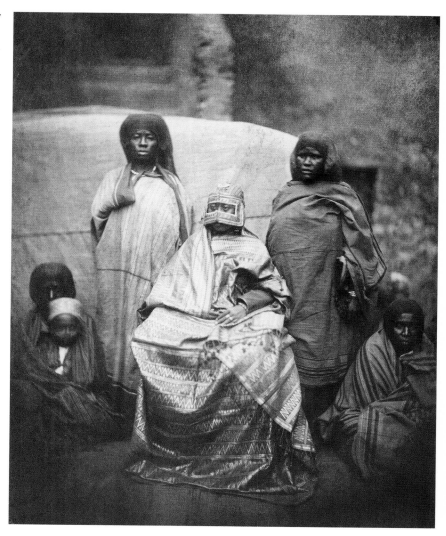

25. Désiré Charnay
La Reine de Mohély
1863

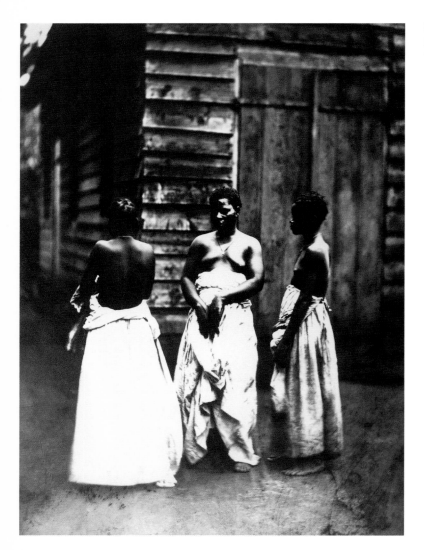

26. Désiré Charnay
Femmes malgaches
1863

27. Désiré Charnay
« Marou – Malgache –
Marou »
1863

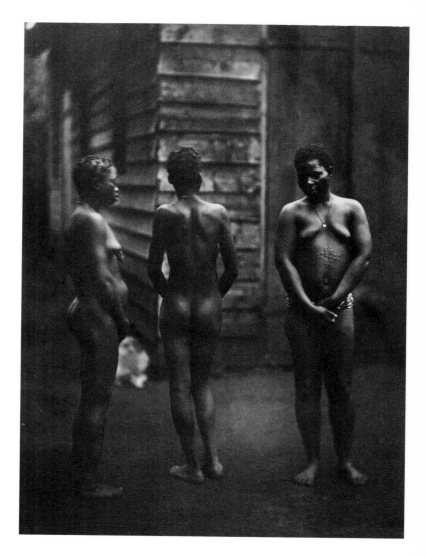

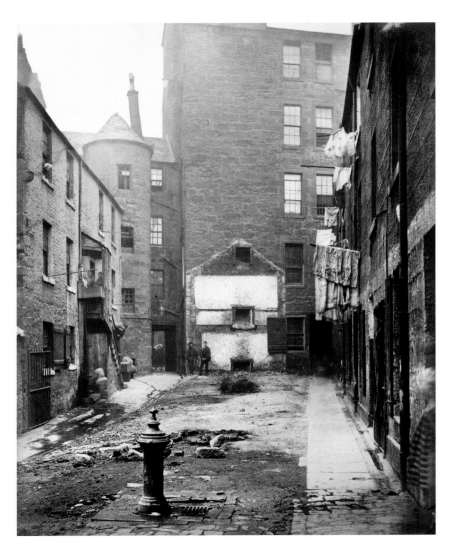

28. Thomas Annan
Glasgow: Closes no. 97 and no.103 Saltmarket
1868

29. Thomas Annan
Glasgow: Close no. 93 High Street
1868

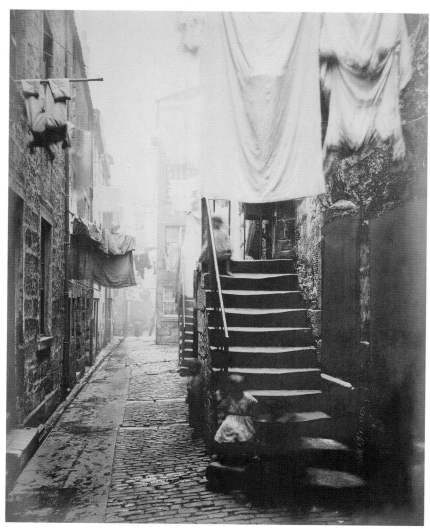

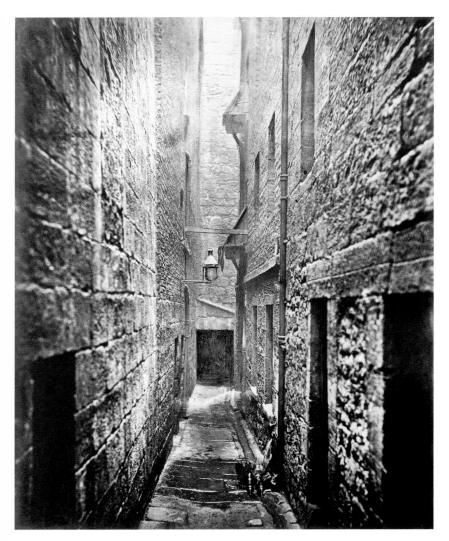

30. Thomas Annan
Glasgow: Close no. 61 Saltmarket
1868

31. Thomas Annan
Glasgow:
Close no. 46
Saltmarket
1868

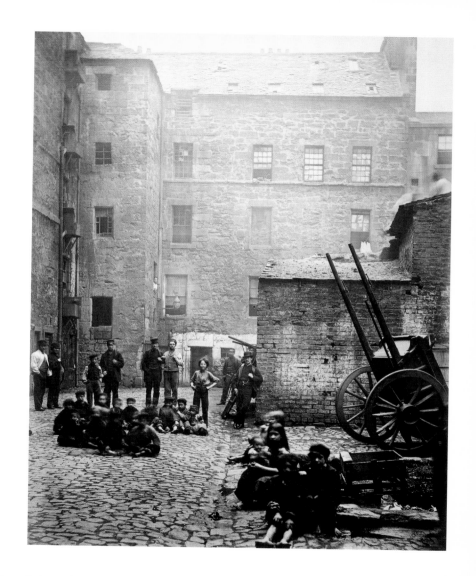

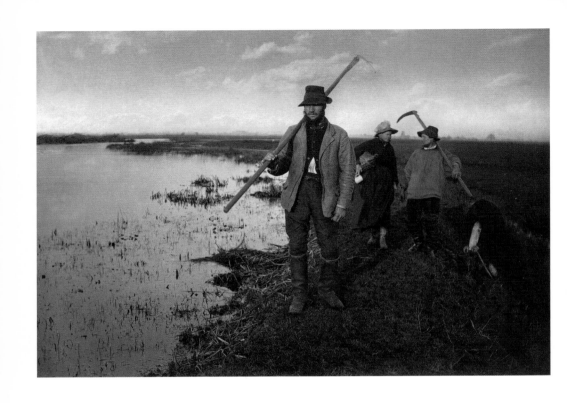

**32. Peter Henry Emerson,
Thomas Frederick Goodall**
Coming Home from the Marshes
1886

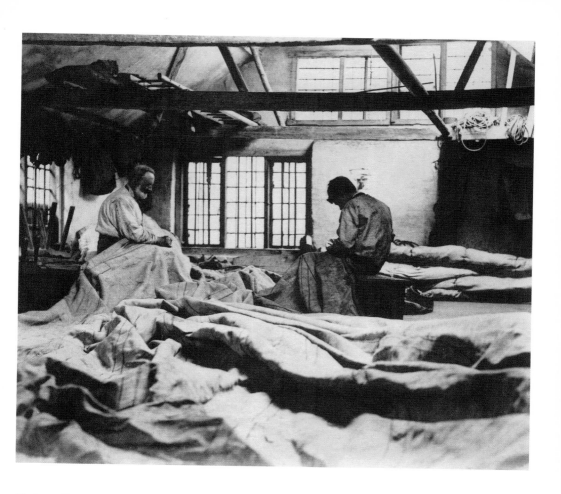

33. Peter Henry Emerson,
Thomas Frederick Goodall
In a Sail Loft
1890

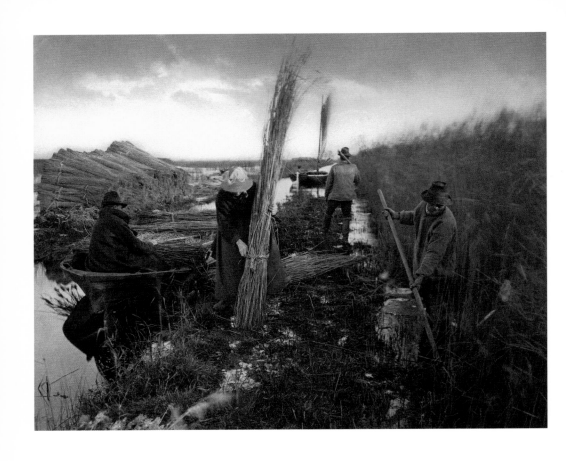

34. Peter Henry Emerson,
Thomas Frederick Goodall
During the Reed Harvest
1886

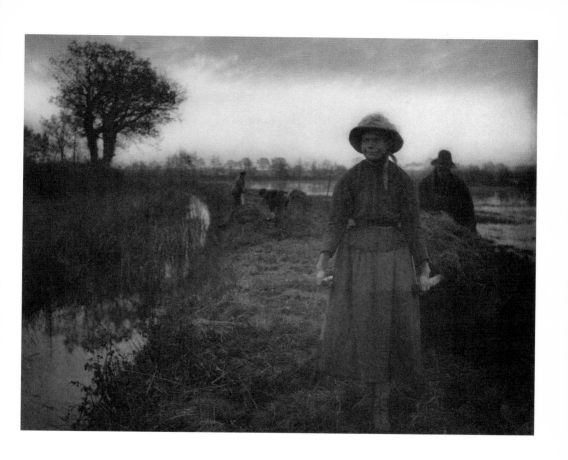

**35. Peter Henry Emerson,
Thomas Frederick Goodall**
Poling in the Marsh Hay
1886

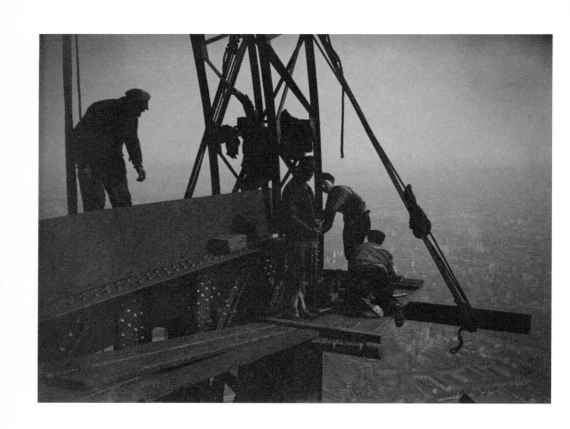

36. Henri Rivière
La Tour Eiffel – Cinq ouvriers
au travail sur une partie du dernier
étage du «campanile»
1889

37. Henri Rivière
La Tour Eiffel –
Ouvrier debout
le long d'une poutre
1889

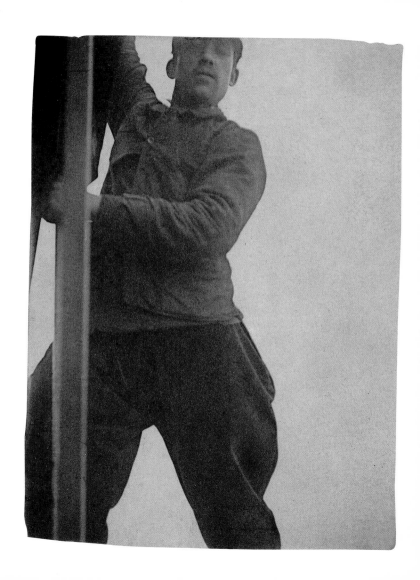

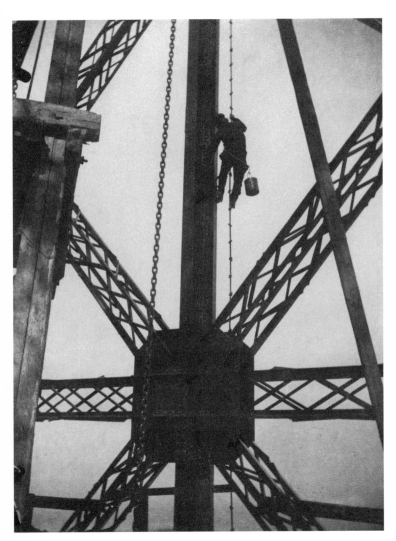

38. Henri Rivière
*La Tour Eiffel – Peintre sur
une corde à nœuds le long
d'une poutre verticale,
au-dessus d'un assemblage
de poutres*
1889

39. Henri Rivière
*La Tour Eiffel – Ouvrier
sur échafaudage travaillant
sur une poutre verticale*
1889

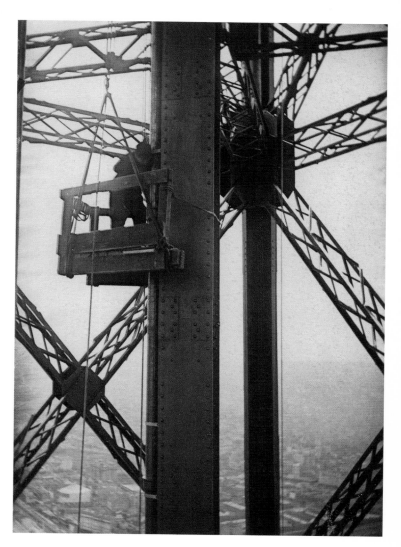

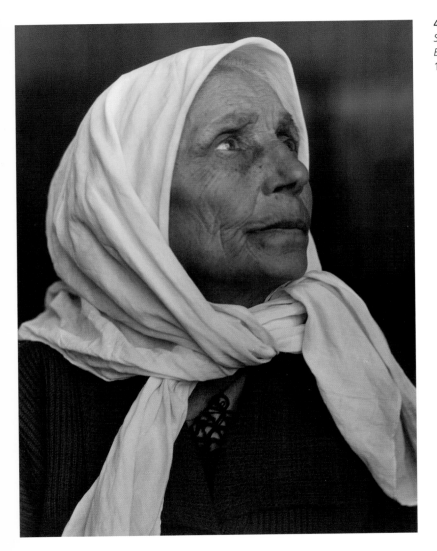

40. Lewis Hine
Syrian Grandmother,
Ellis Island, New York
1926

41. Lewis Hine
Italian Mother,
Ellis Island
1905

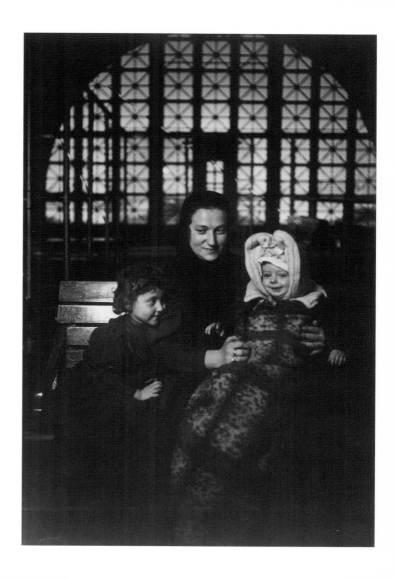

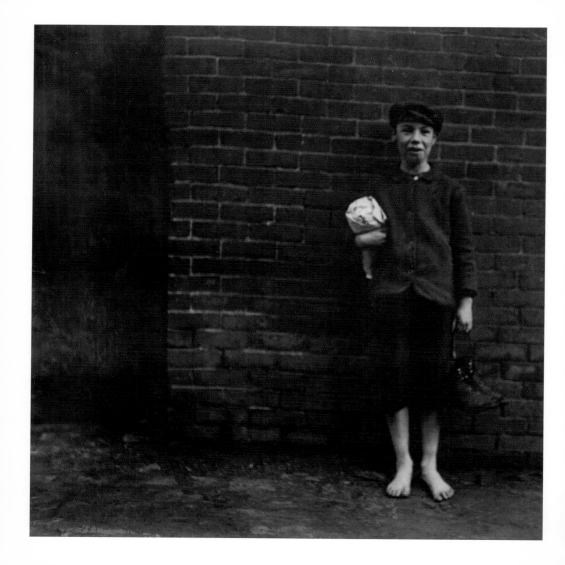

42. Lewis Hine
*A Sweeper
in the Hill
Factory, Lewston,
I saw him
working inside*
1909

43. Lewis Hine
*Young Boys
Selling
Newspapers*
1910

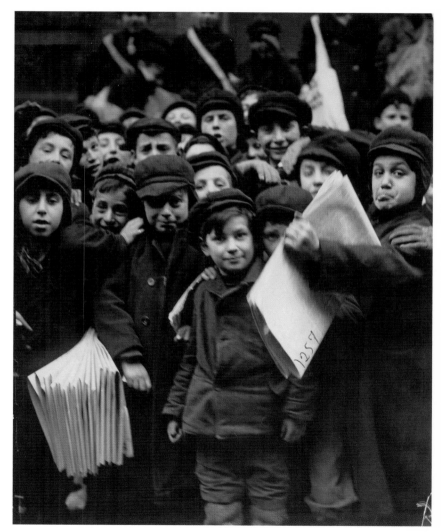

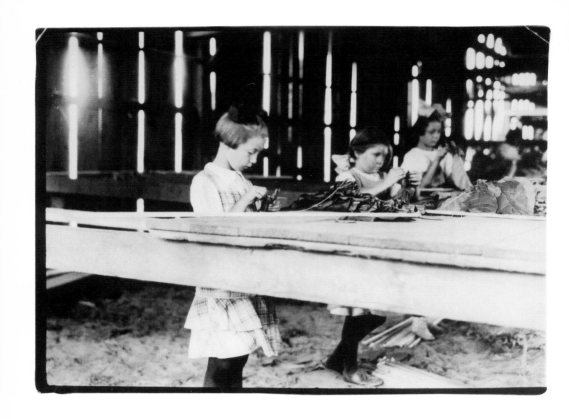

44. Lewis Hine
Hazerville, Interior of Tobacco Shed,
Hawthorn Farm, girls in foreground,
the ten-year-old makes 50 cents a day,
twelve workers in this farm
are eight to fourteen years old,
and about fifteen are fifteen years old
1905/1910

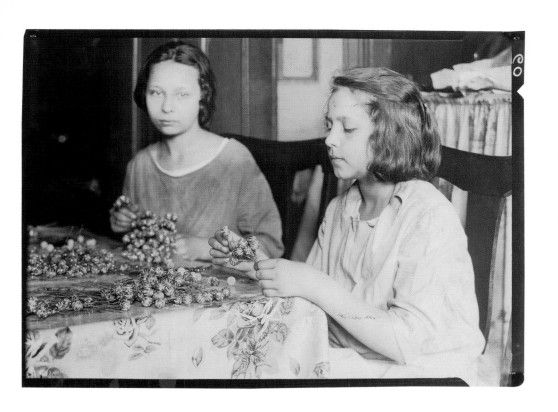

45. Lewis Hine
Tenement Workers Making Ornaments
1905/1910

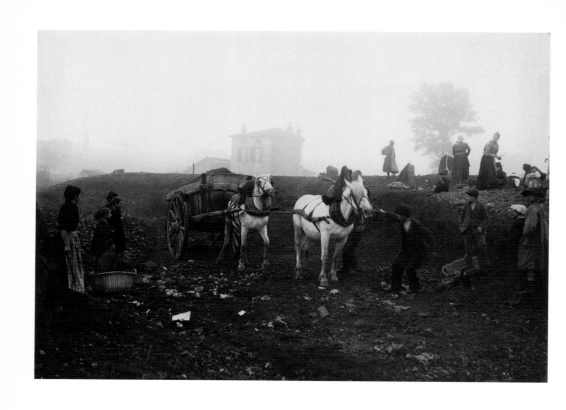

46. Félix Thiollier
Grappilleurs sur une mine
à Saint-Étienne
1890/1900

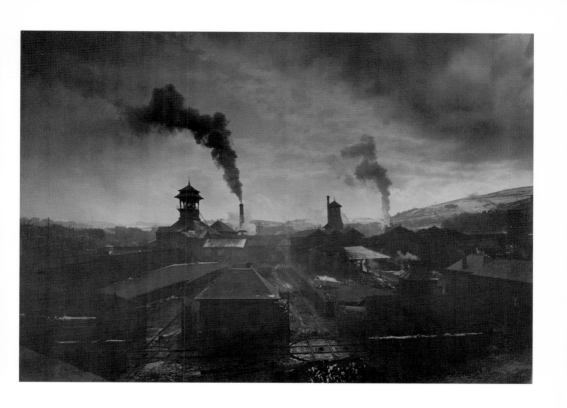

47. Félix Thiollier
Mine à Terrenoire
ca. 1895

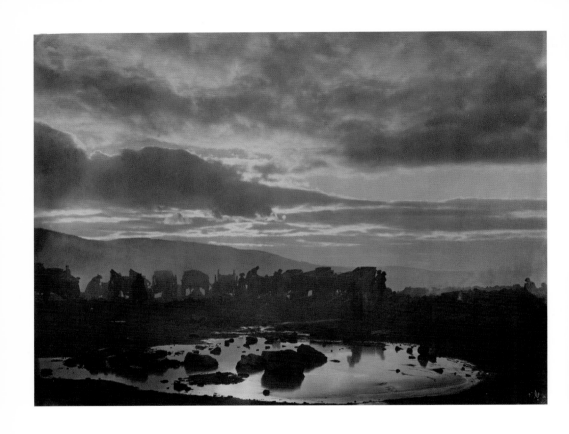

48. Félix Thiollier
Grappilleurs au couchant
près de Saint-Étienne
ca. 1895

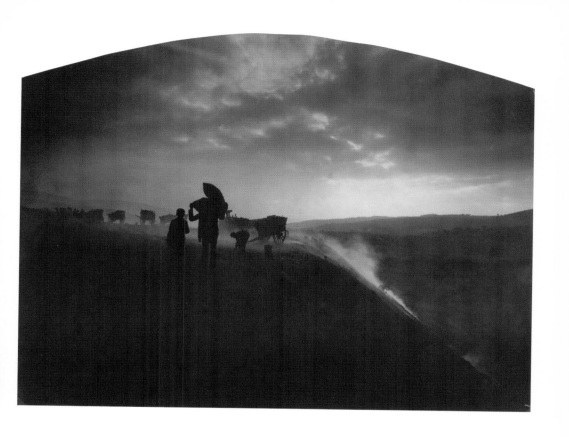

49. Félix Thiollier
Grappilleurs sur le terril
à Saint-Étienne
ca. 1895

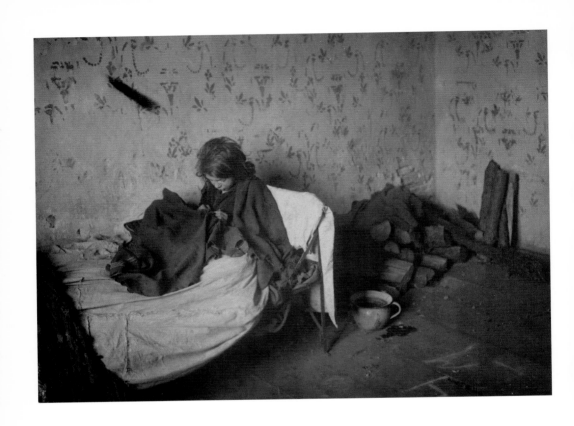

50. Anonyme
Fillette cousant sur son lit
ca. 1919

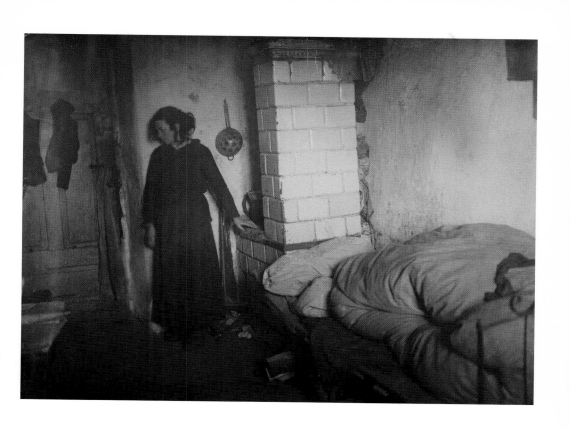

51. Anonyme
Jeune femme dans son intérieur
ca. 1919

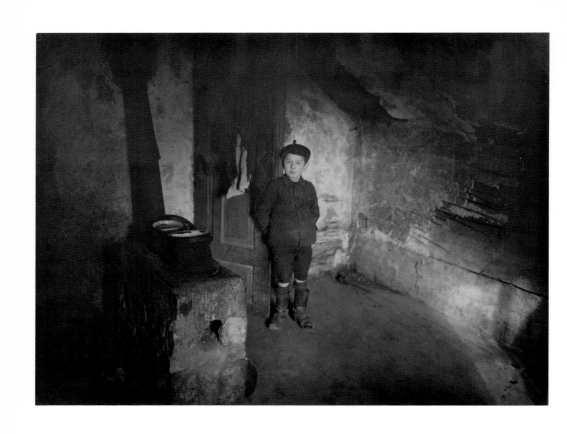

52. Anonyme
Petit garçon,
debout dans une chambre
ca. 1919

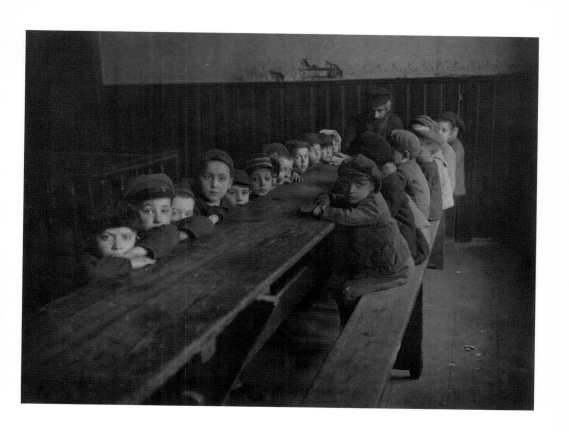

53. Anonyme
École juive
ca. 1919

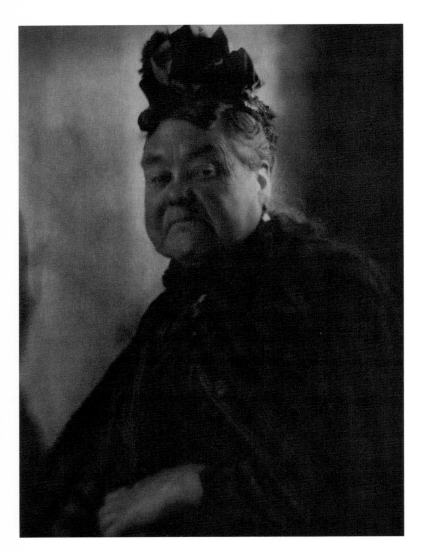

54. Baron Adolphe De Meyer
*Mrs Wiggins
of Belgrave Square*
1912

55. Baron Adolphe De Meyer
The Balloon Man
1912

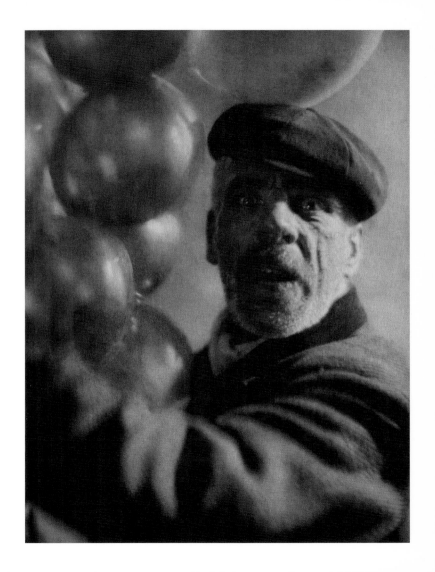

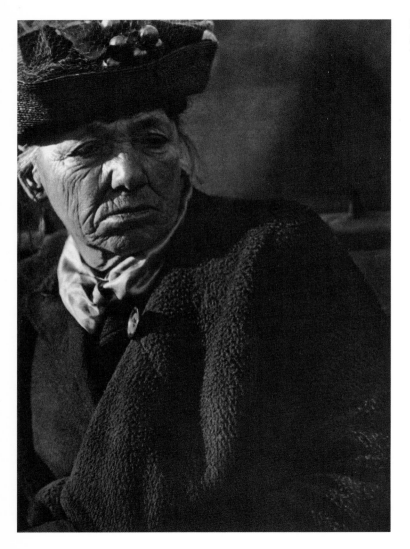

56. Paul Strand
Photograph – New York
1917

57. Paul Strand
Photograph – New York
1917

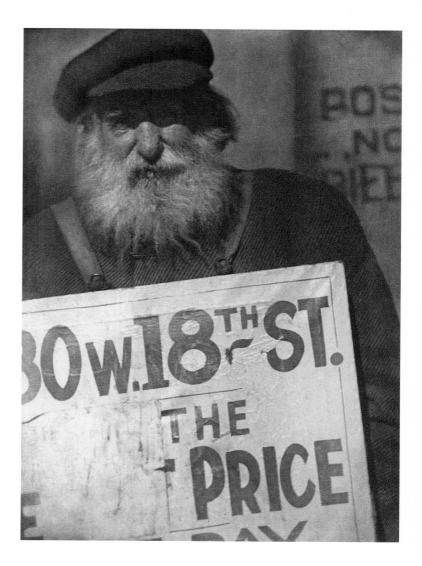

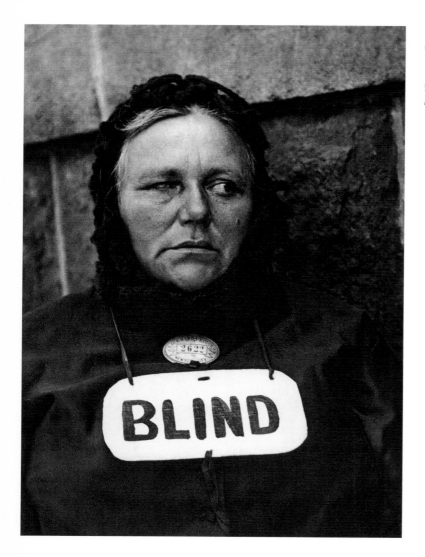

58. Paul Strand
Photograph – New York
1917

59. Paul Strand
Photograph – New York
1917

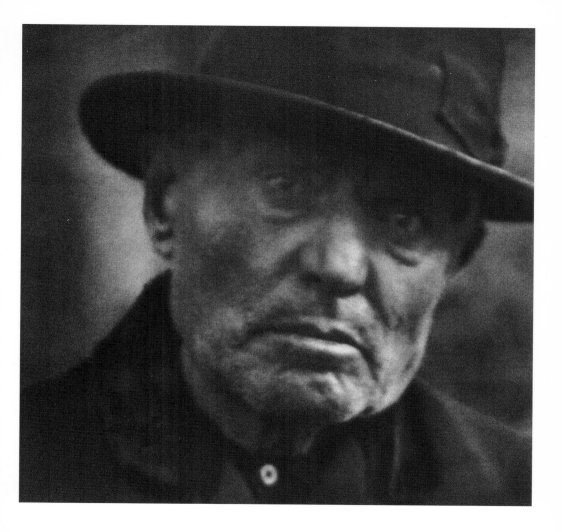

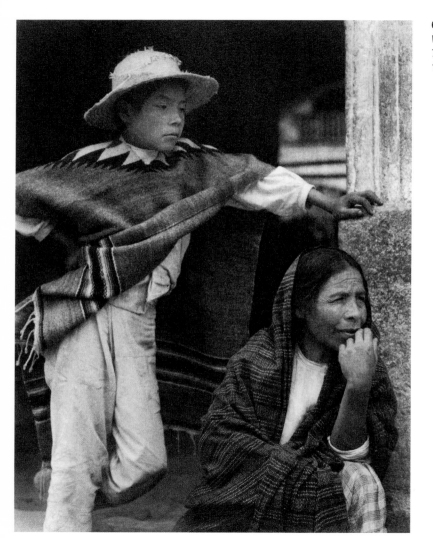

60. Paul Strand
Woman and Boy,
Terrancingo
1932-1933

61. Paul Strand
Boy, Hidalgo
1932-1933

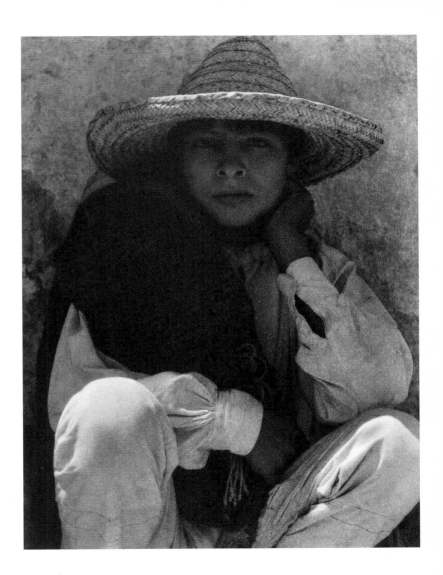

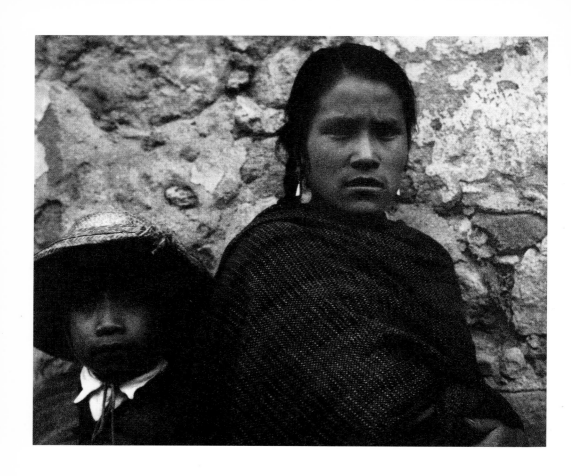

62. Paul Strand
Young Woman and Boy, Toluca
1932-1933